"

PAESAGGI

DI

CARTONE "

Fotografie dal 1971 - 1973

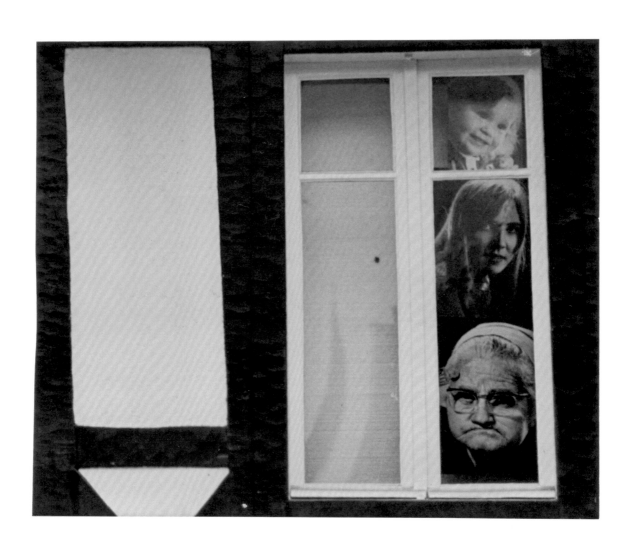

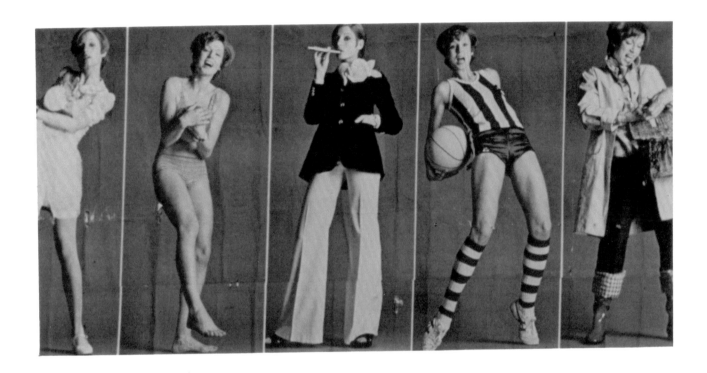

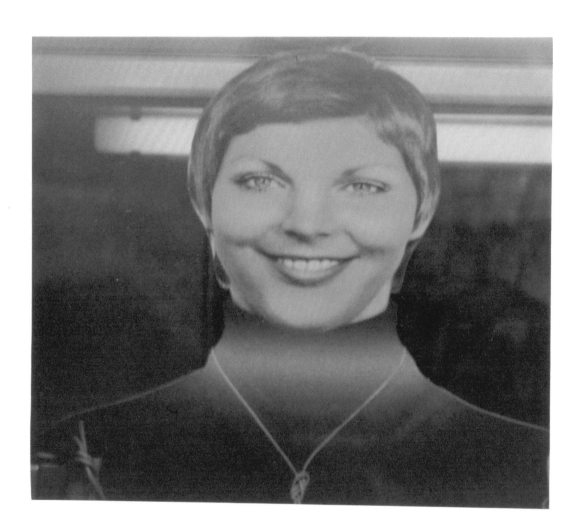

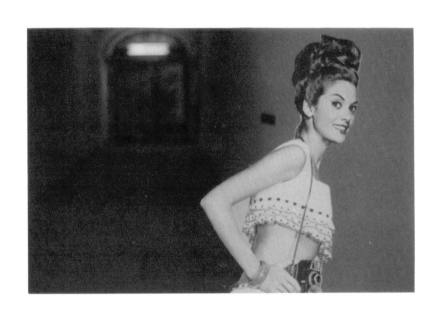

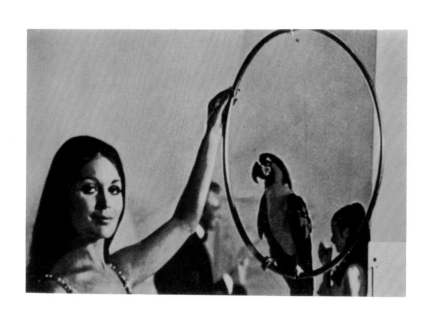

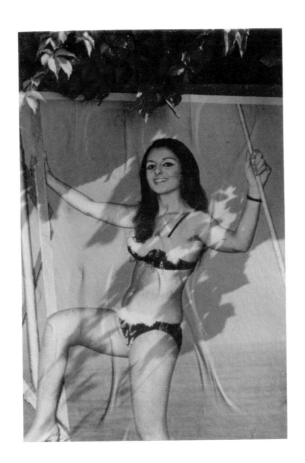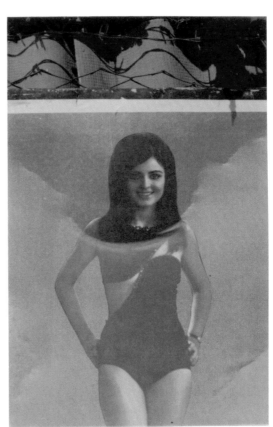

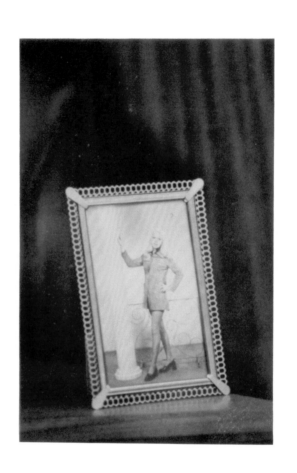

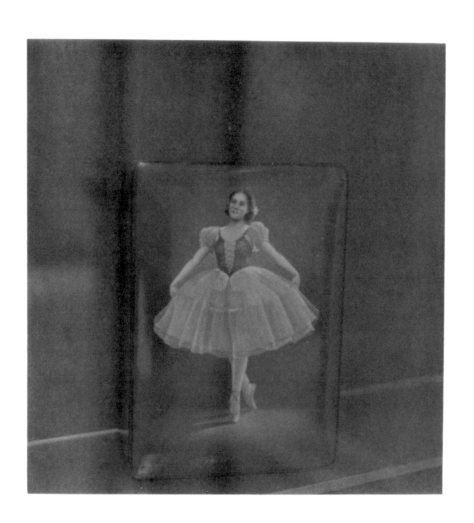

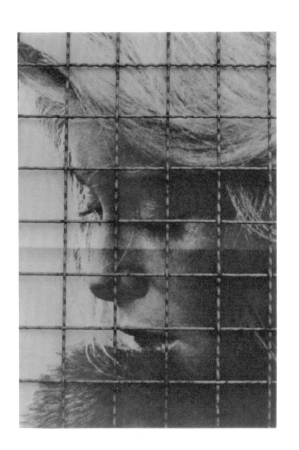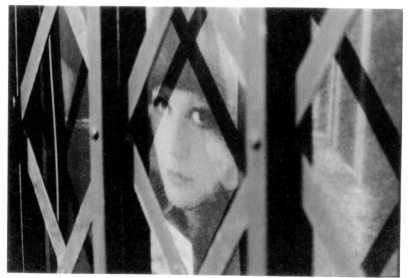

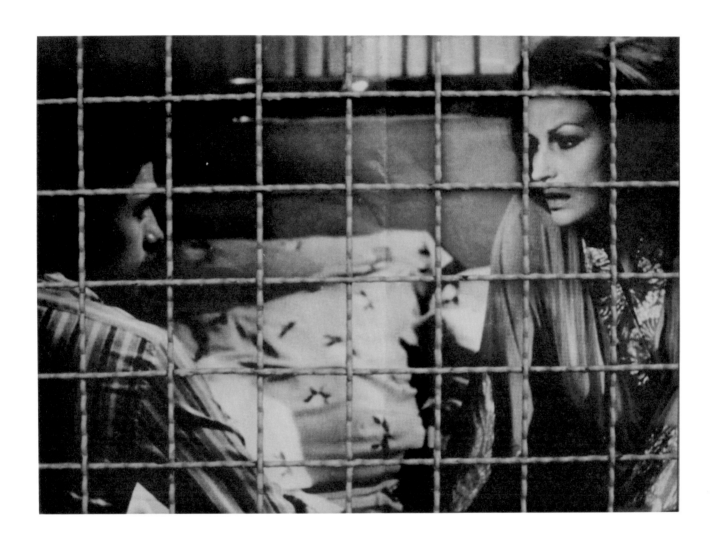

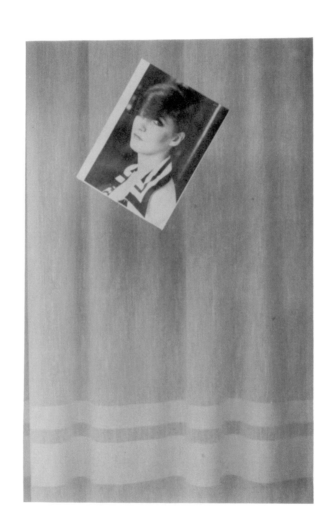

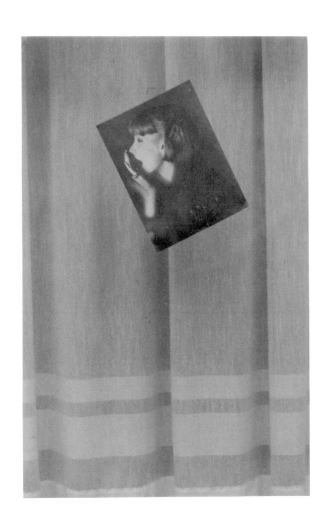

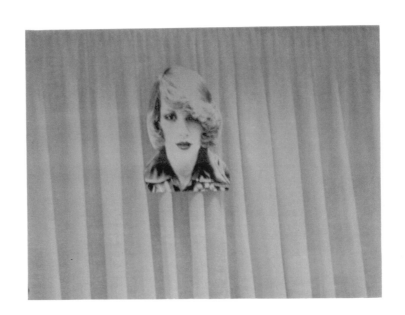

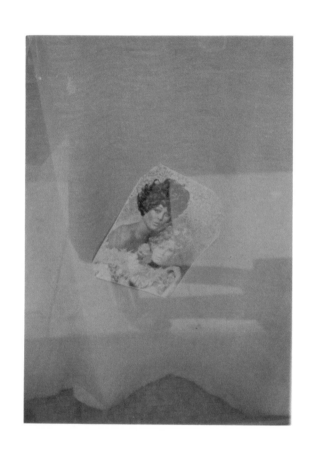

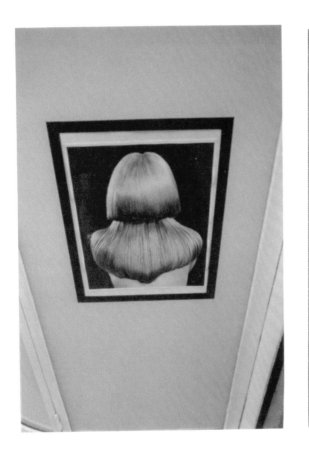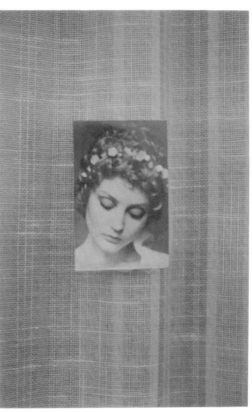

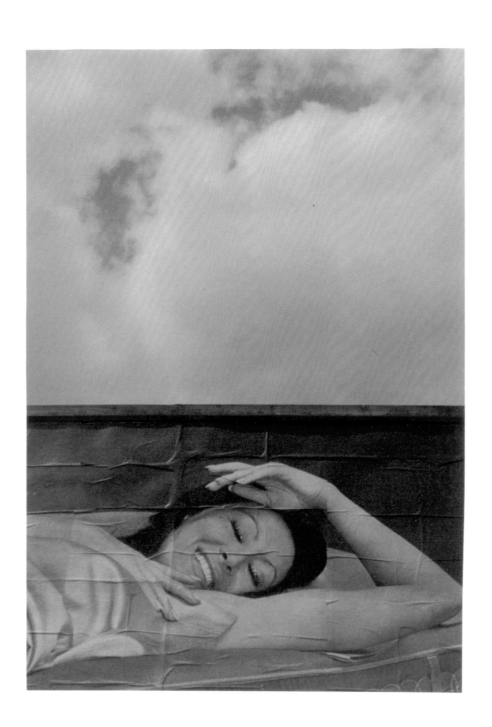

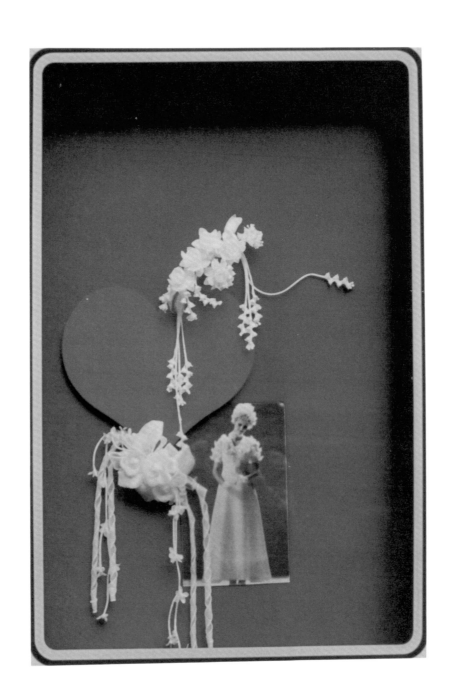

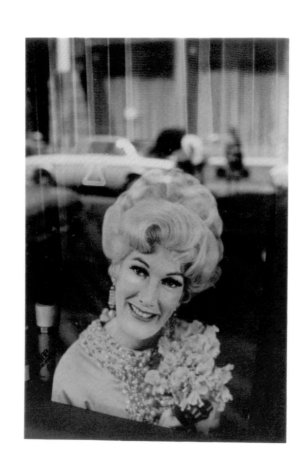

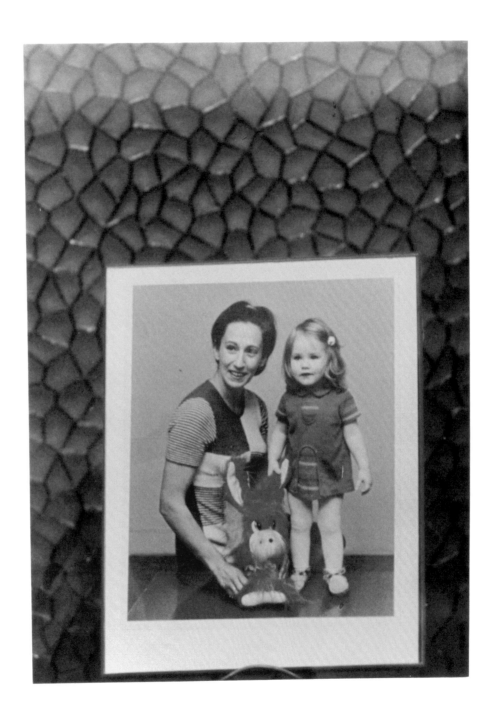

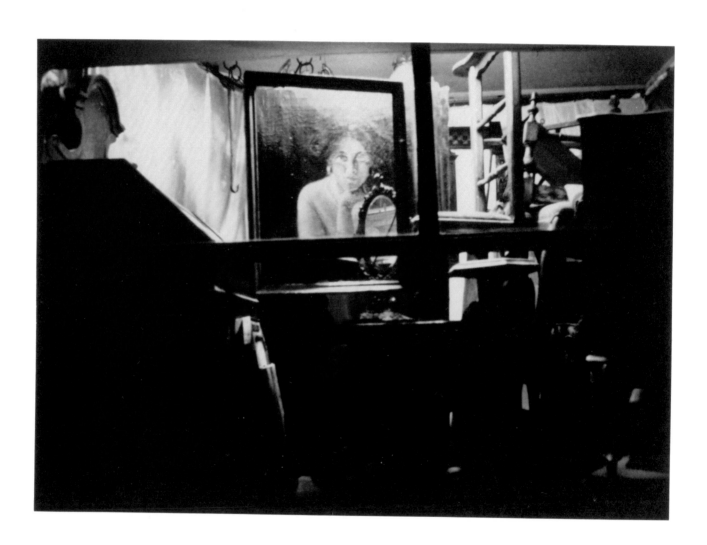

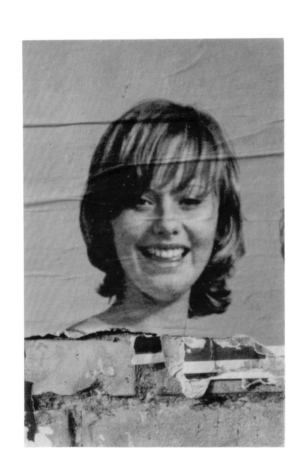

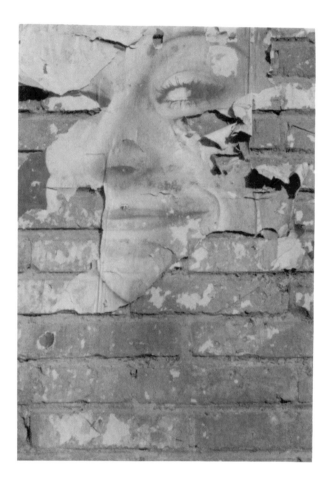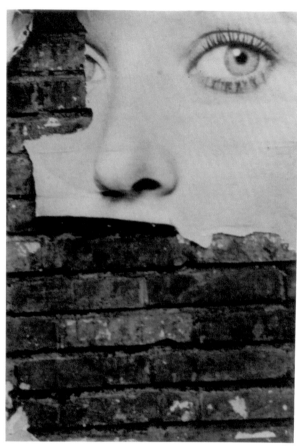

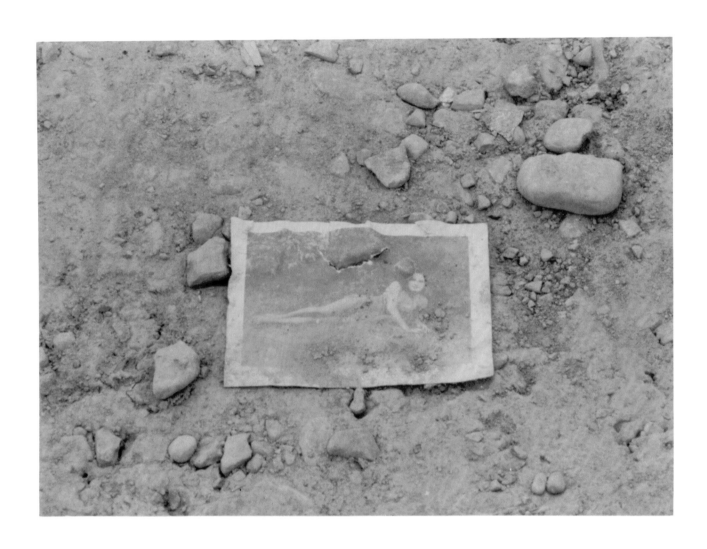

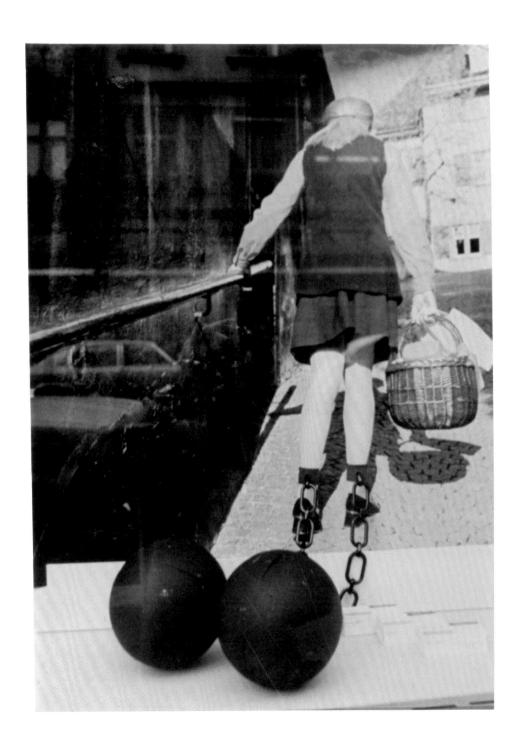

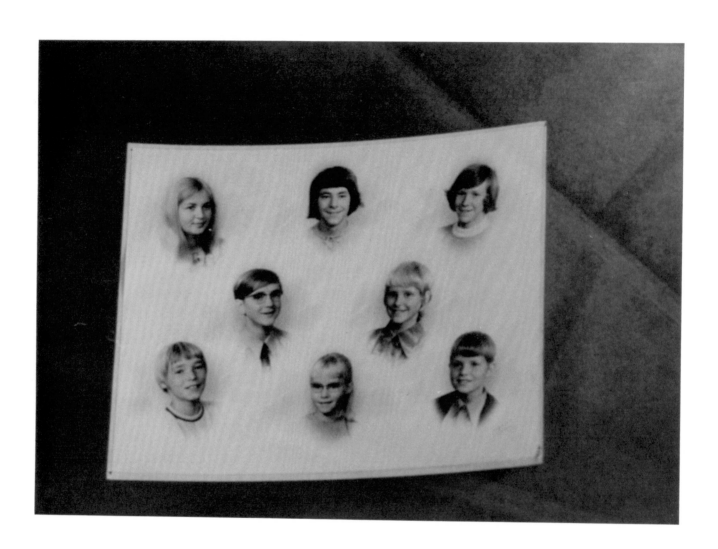

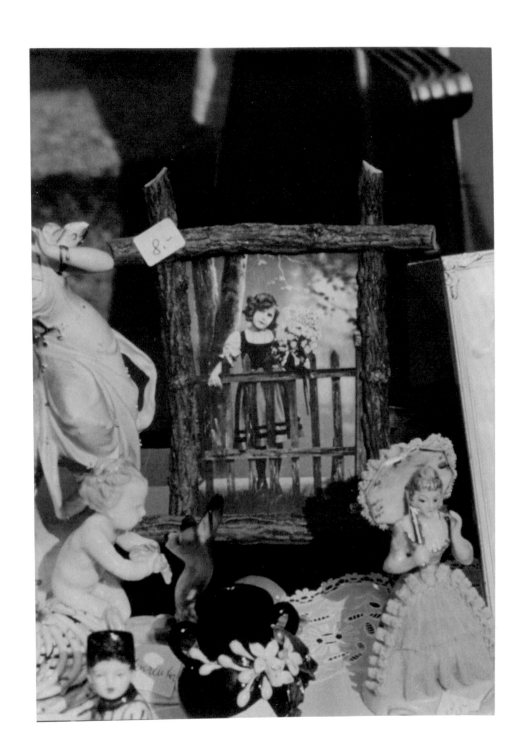

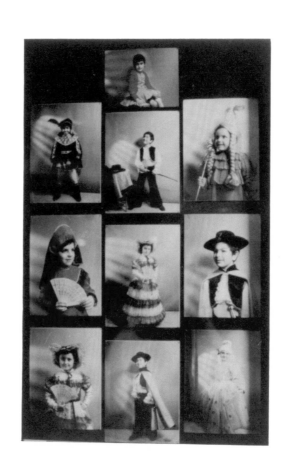

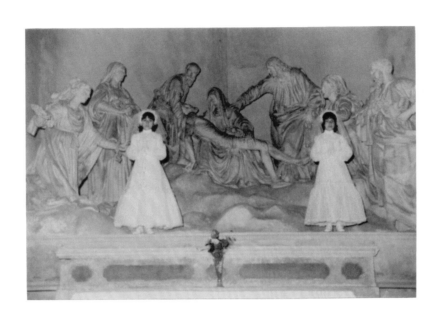

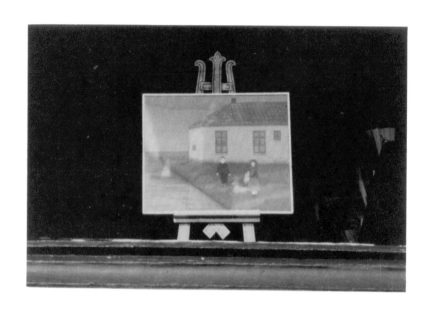

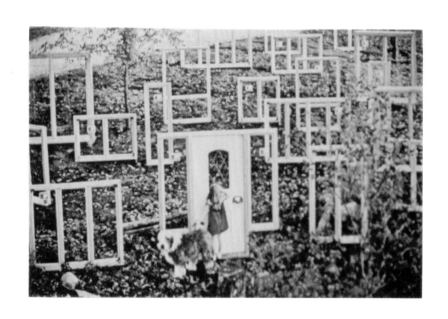

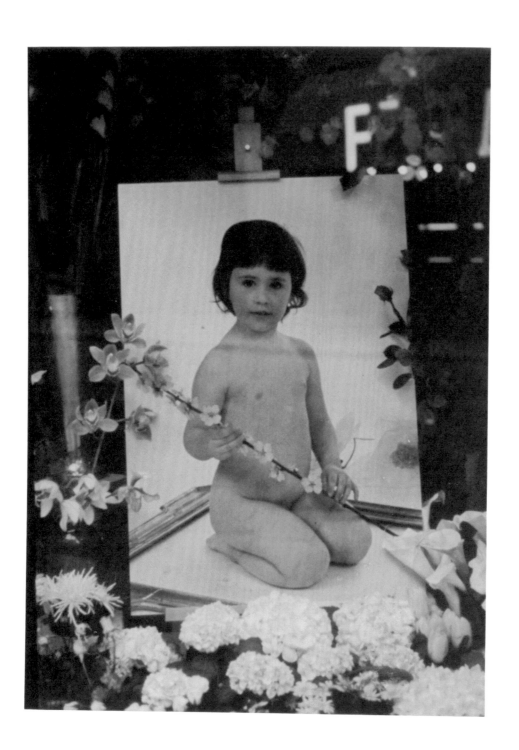

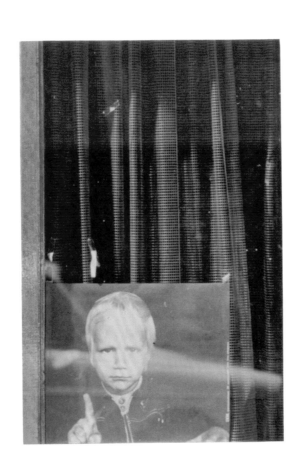

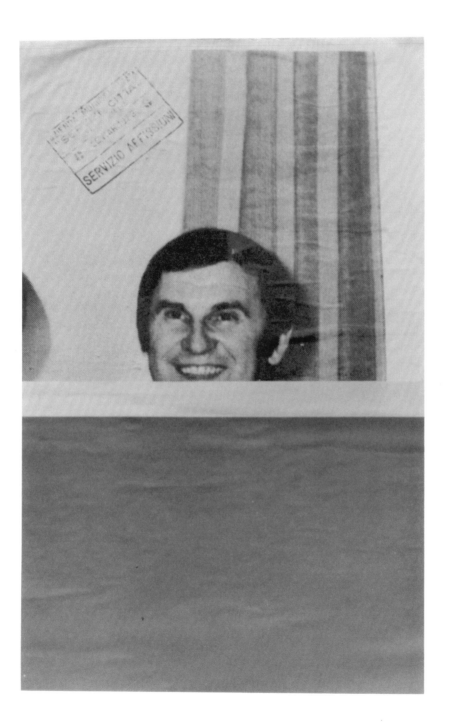

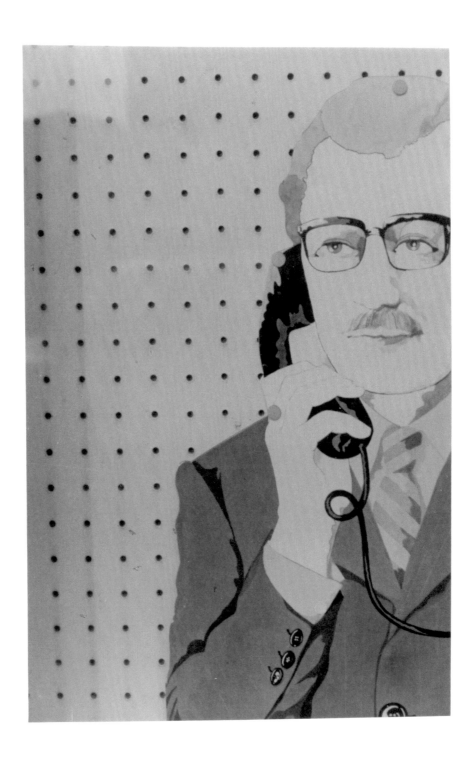

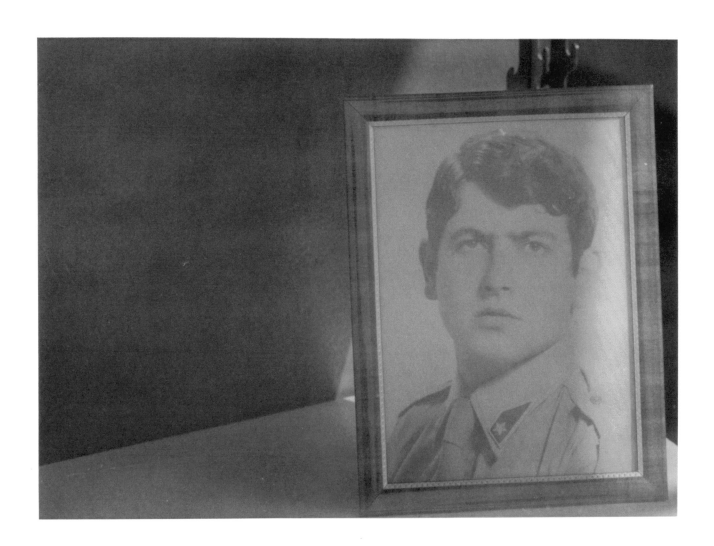

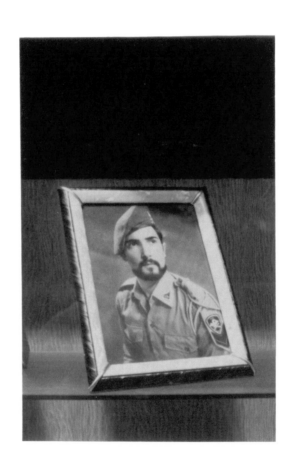

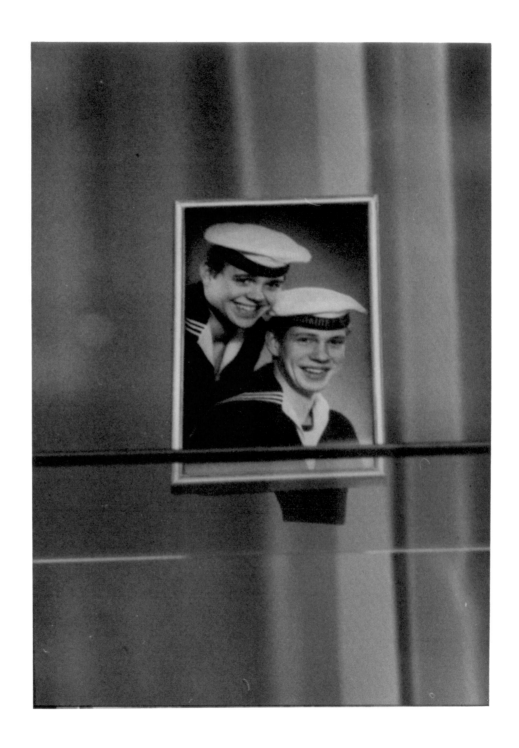

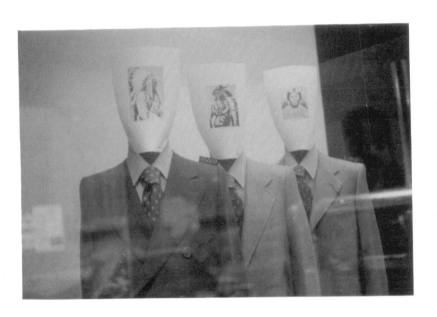

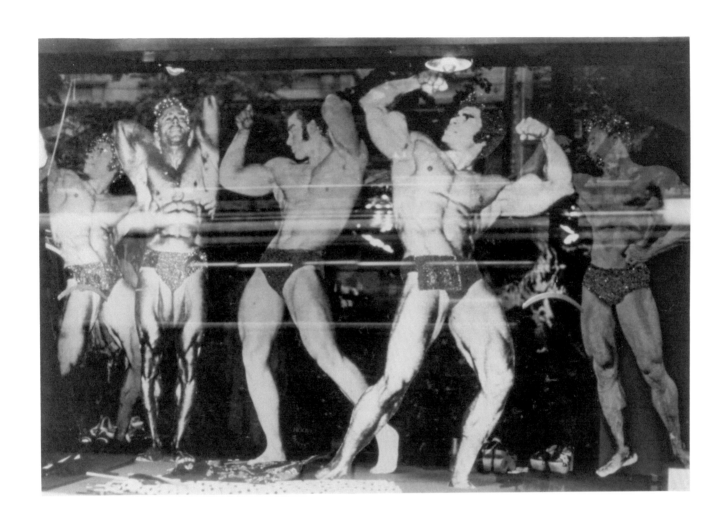

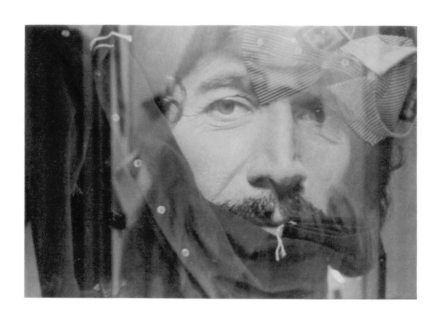

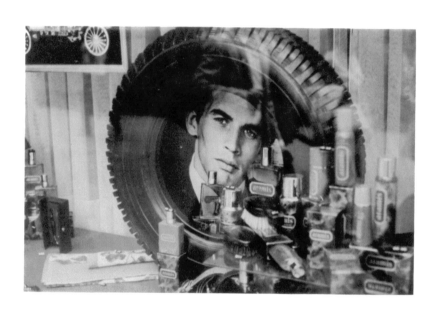

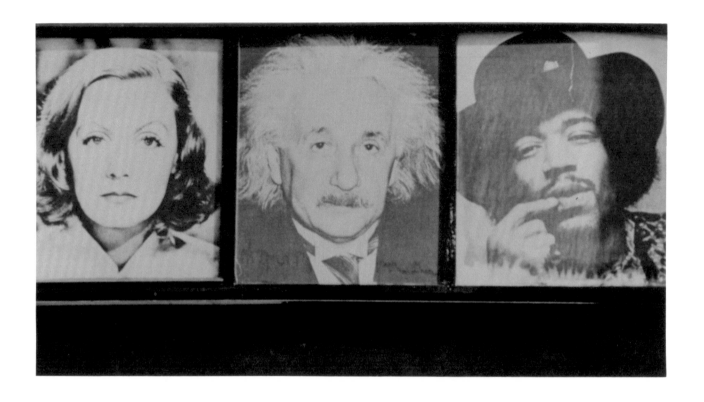

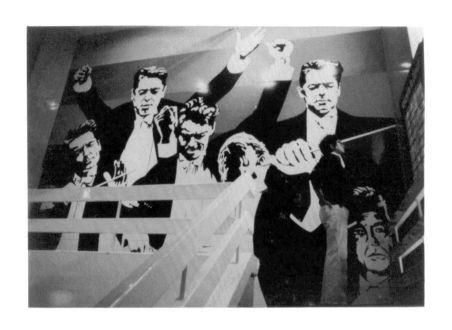

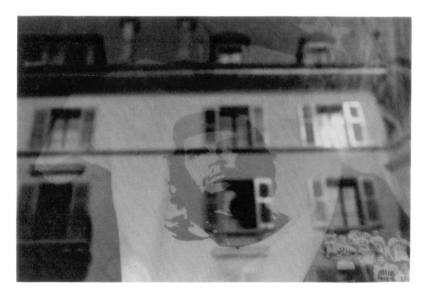

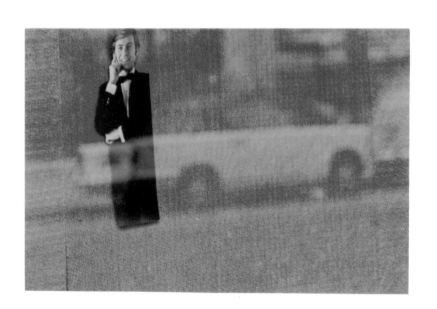

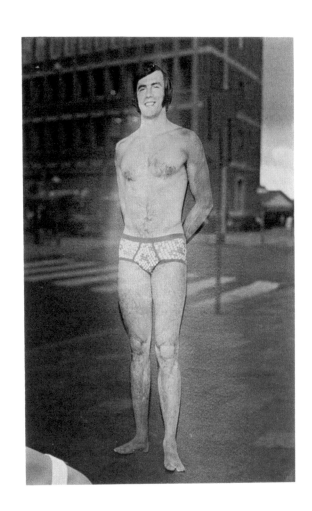

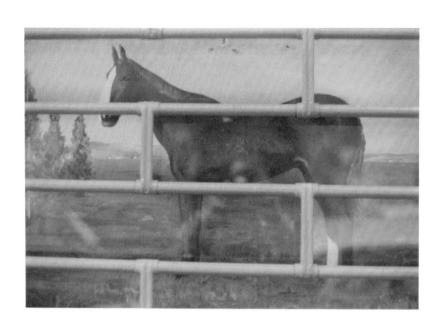

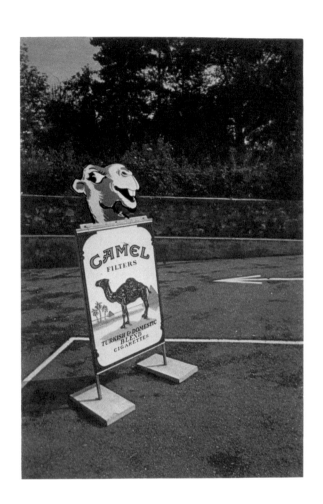

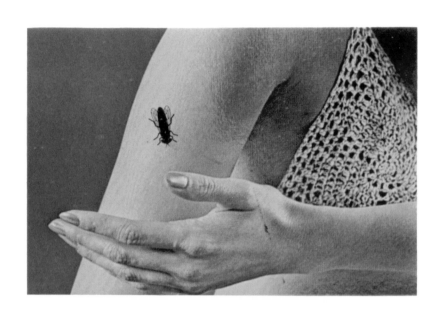

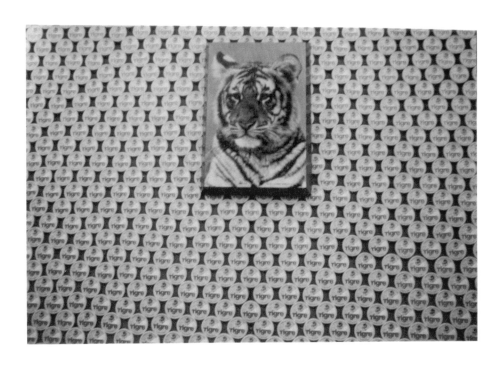

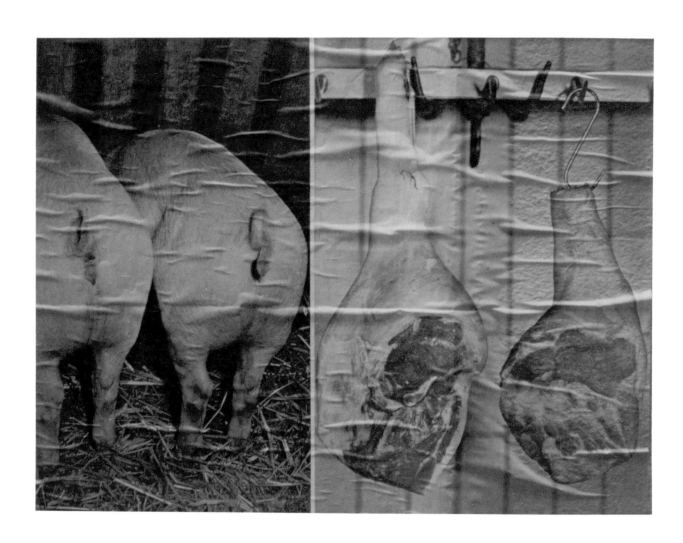

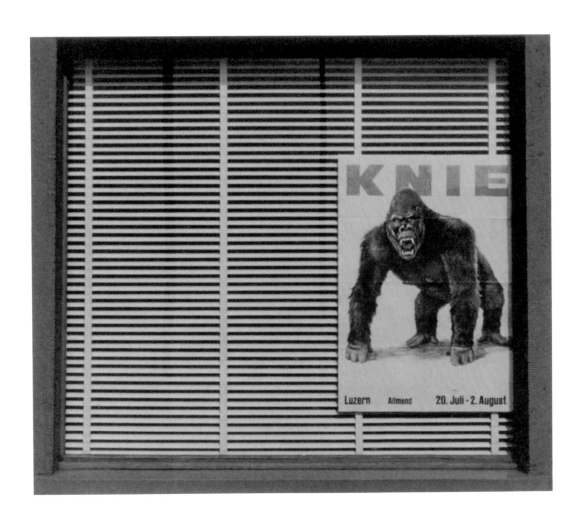

KNIE

Luzern Allmend 20. Juli – 2. August

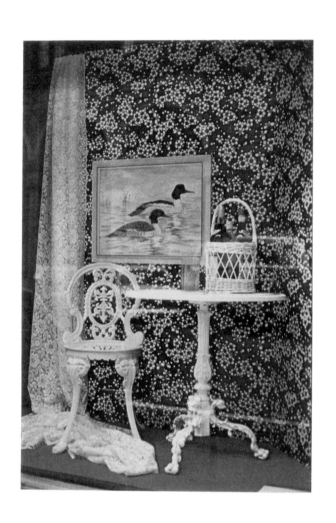

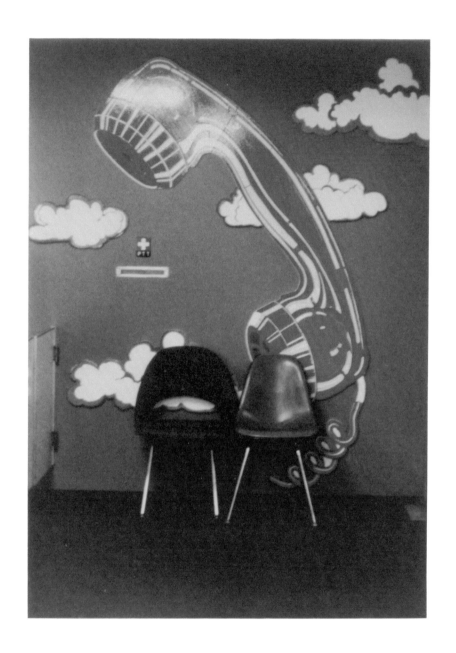

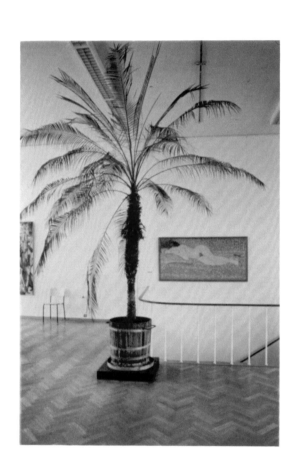

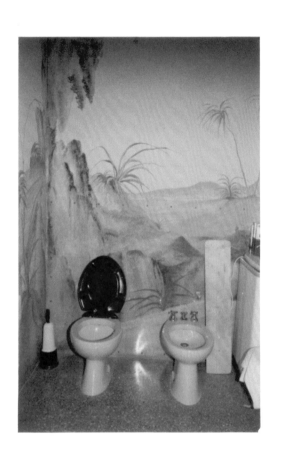

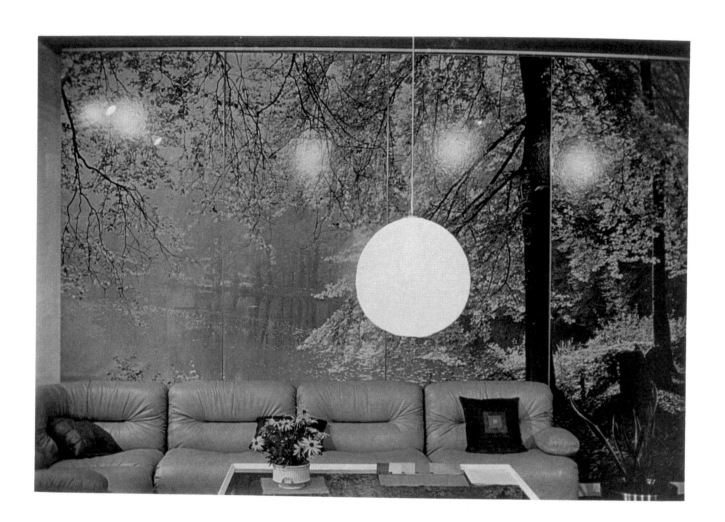

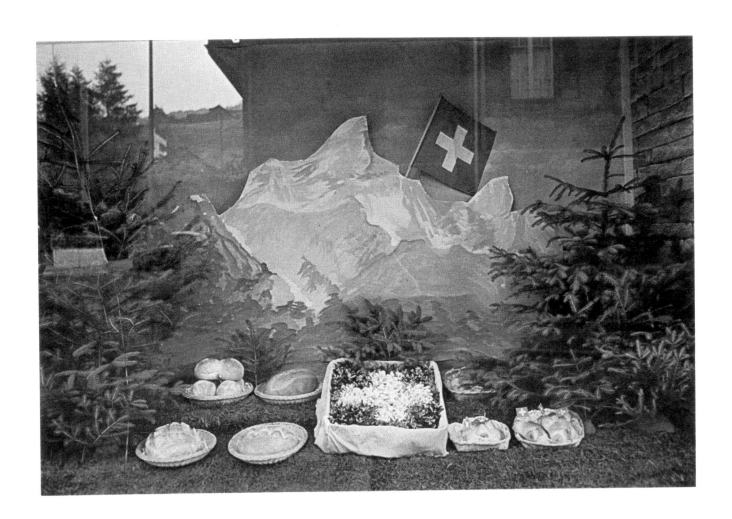

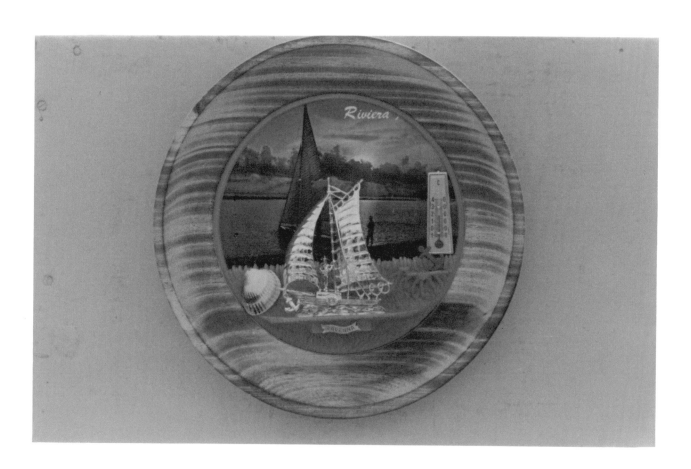

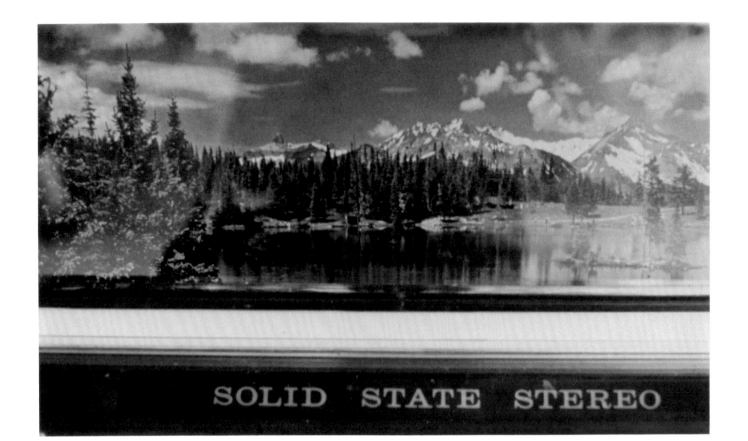

SOLID STATE STEREO

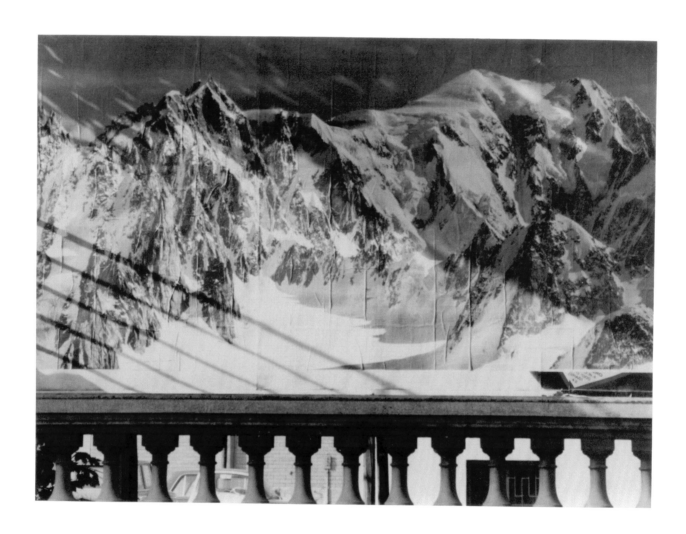

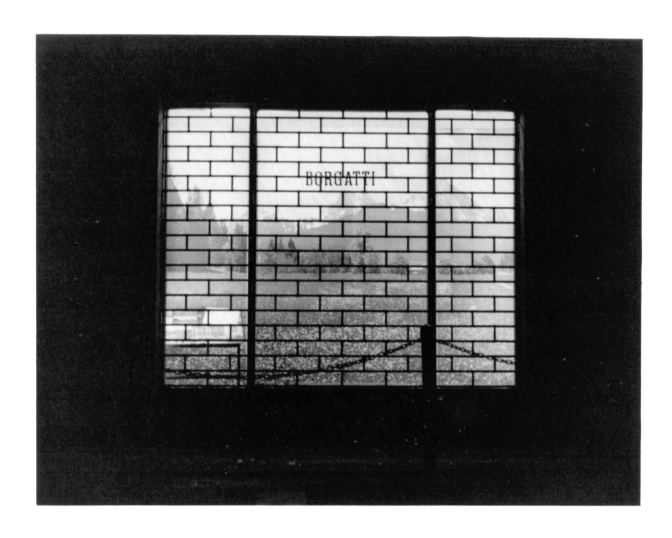

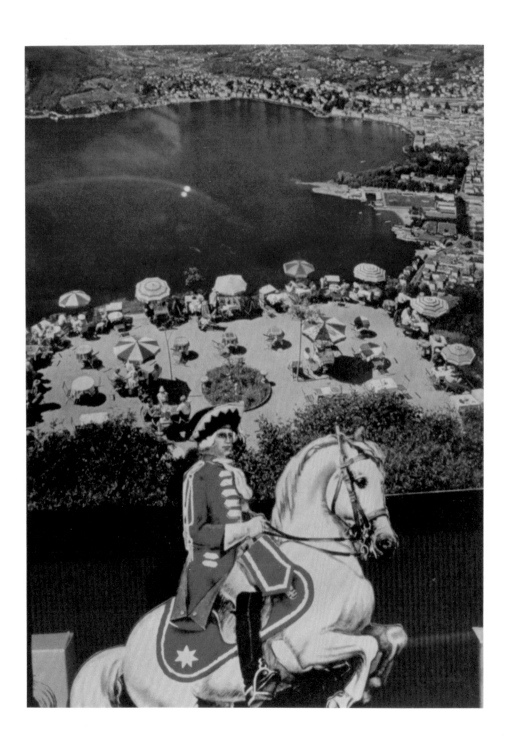

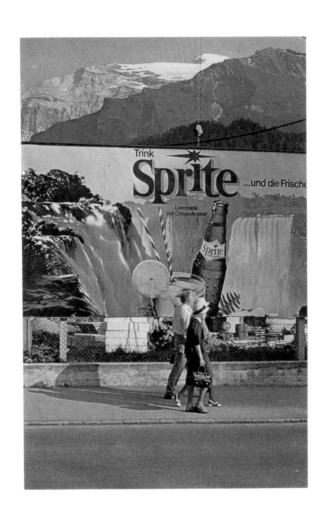

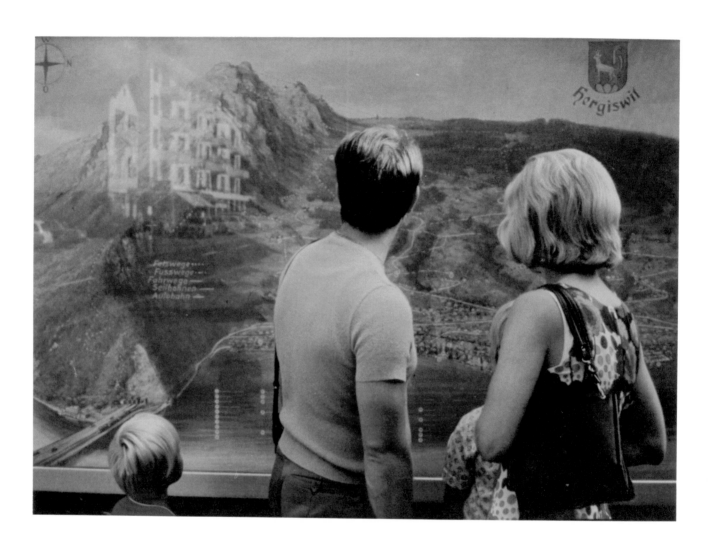

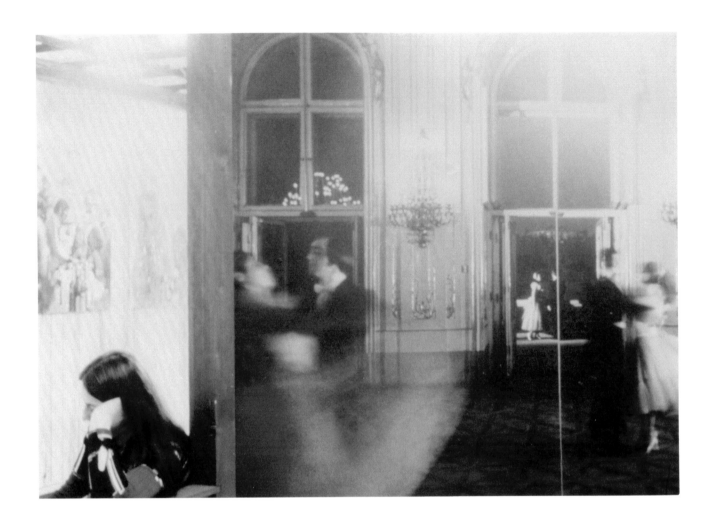

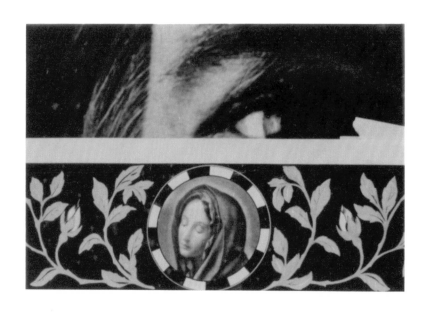

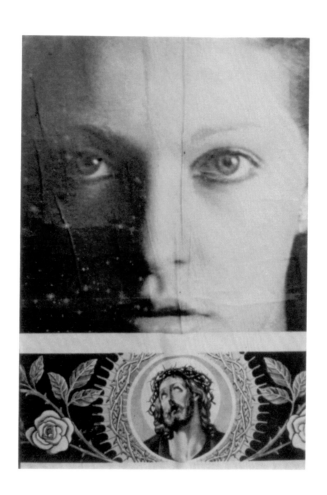

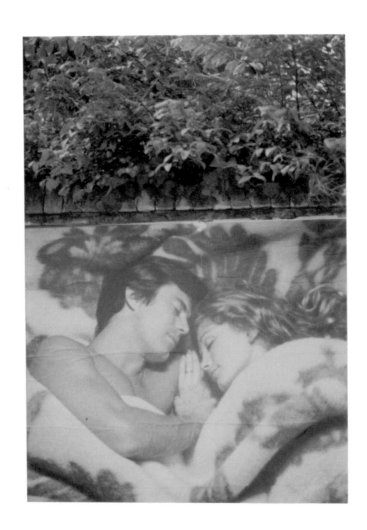

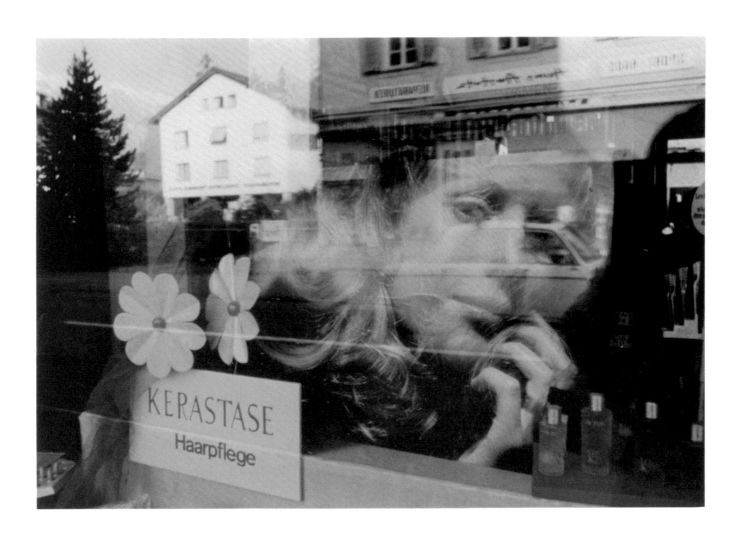

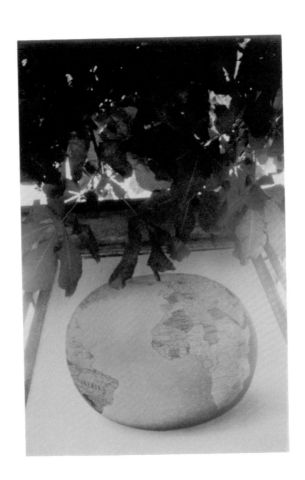

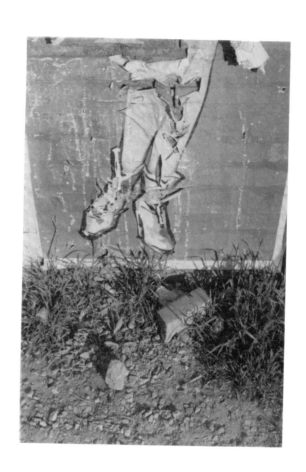

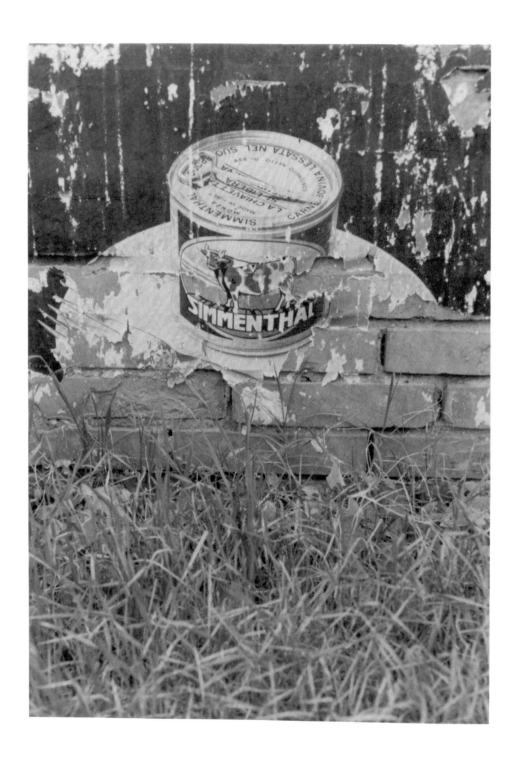

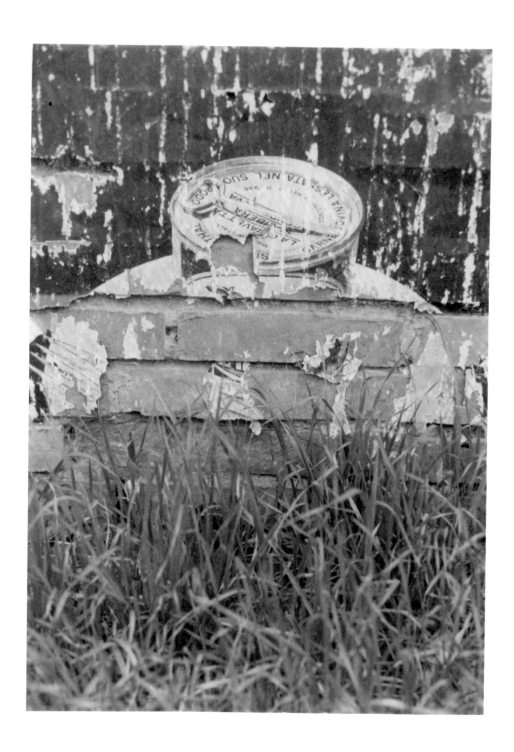

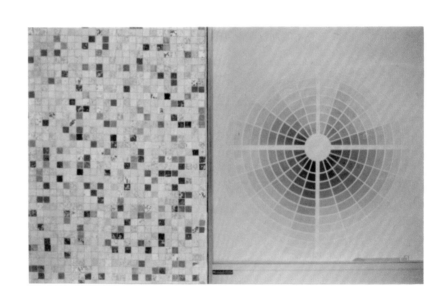

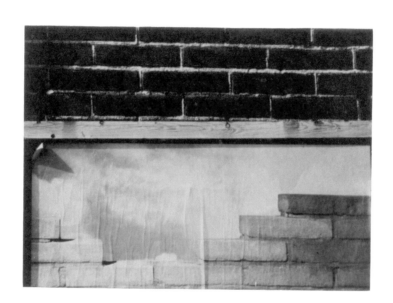

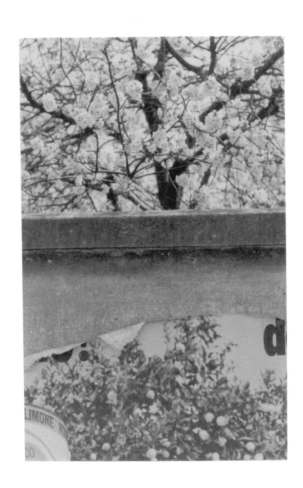

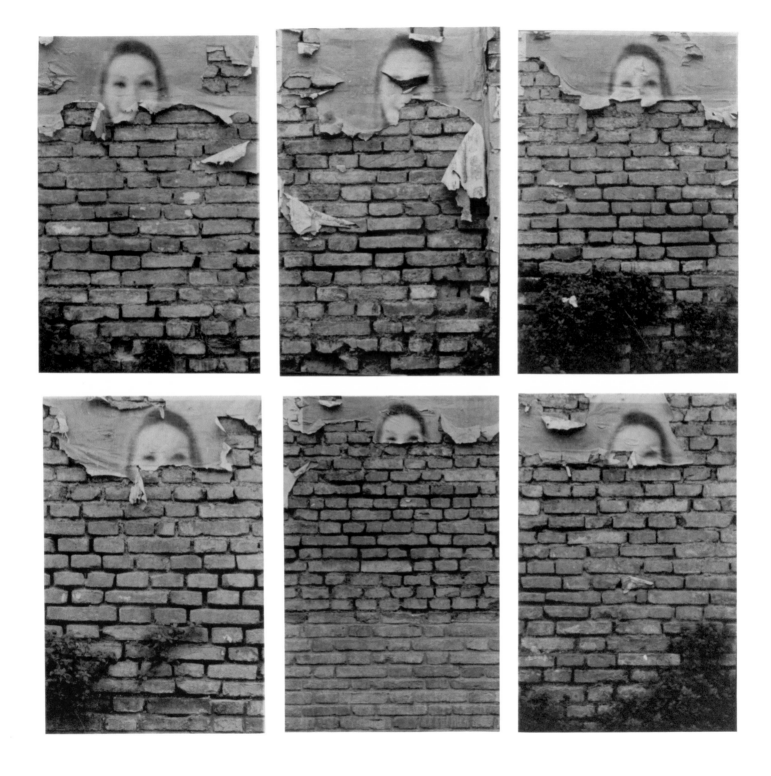

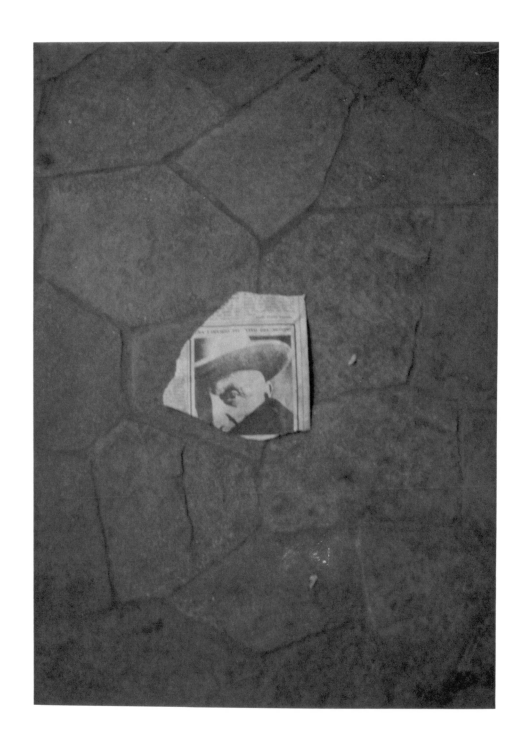

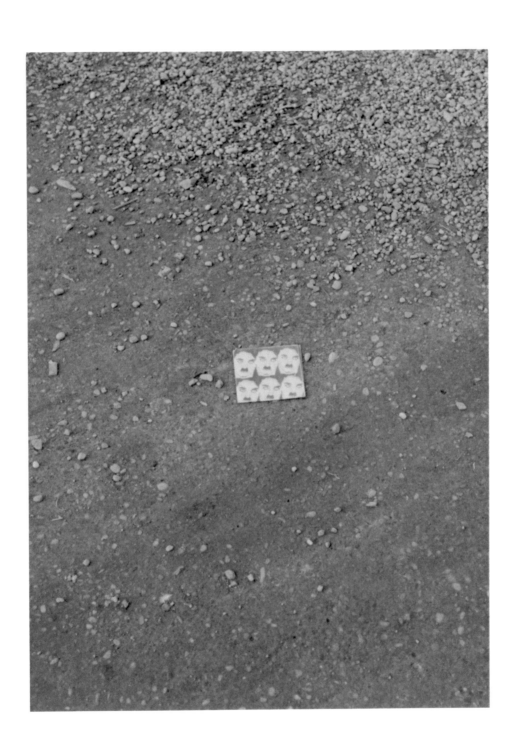

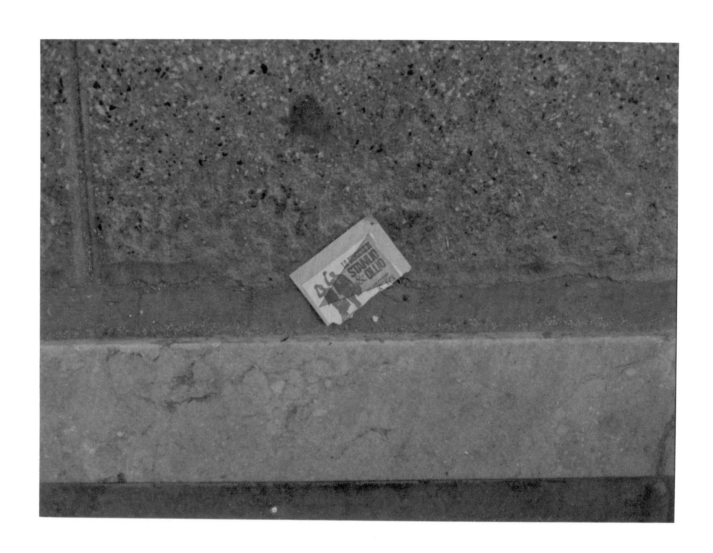

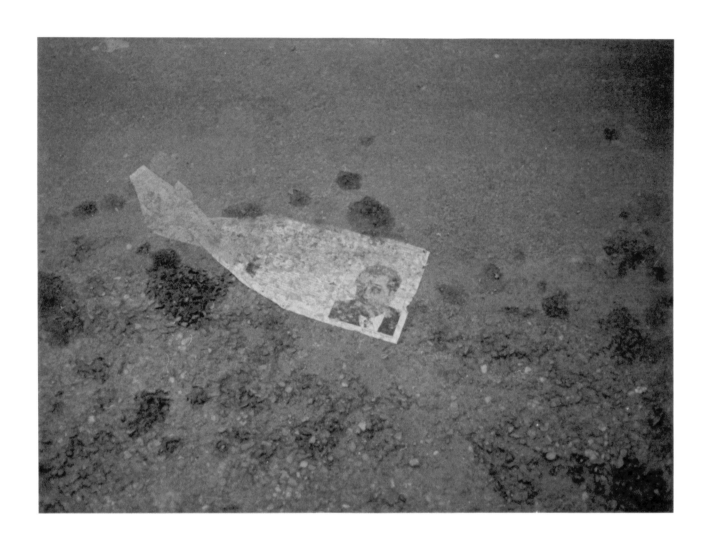

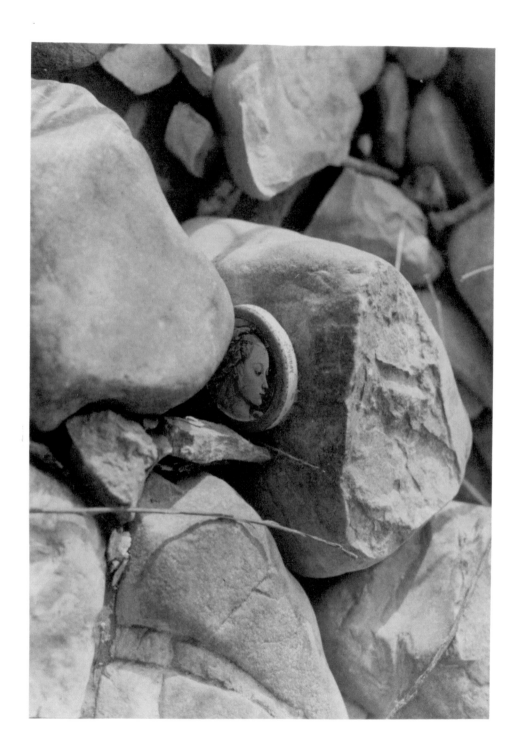

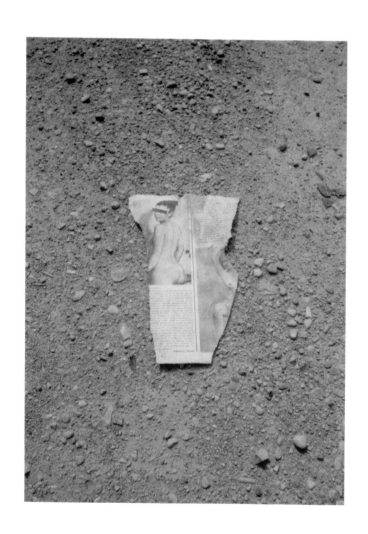

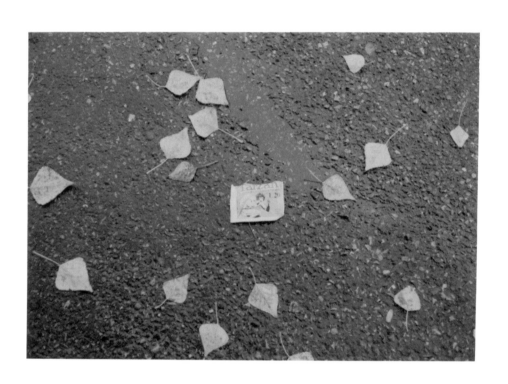

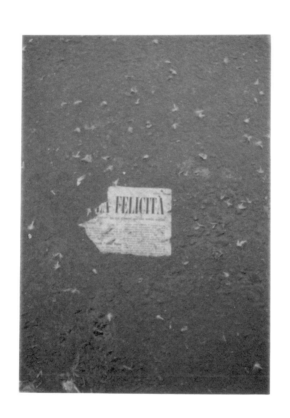

Luigi Ghirri Cardboard Landscapes

Photographs from 1971–73

With a note on the facsimile edition by
Sarah Hermanson Meister

The Museum of Modern Art, New York

A Note on the Facsimile Edition

YOU HOLD IN YOUR HANDS a faithful reproduction of *Paesaggi di cartone*, or *Cardboard Landscapes*, a marvelous album of photographs by the Italian artist Luigi Ghirri (1943–1992). In all essential details, the original album and this facsimile edition are identical: both are bound between Florentine-paper covers laced with bronze metallic skeins and set against rough oatmeal linen spines; they share the same, nearly square dimensions and present 111 prints arranged in the same sequence over the course of fifty pages. In the facsimile as in the original, the only words that appear were inscribed by Ghirri himself, in blue ballpoint pen (not counting the typeset pages, including the one you are reading, inserted into the facsimile after the final photograph).

The album came into the possession of The Museum of Modern Art in New York in 1975, when it was delivered personally to John Szarkowski, then director of the Department of Photography, by Arturo Carlo Quintavalle, a professor and director of the Study Centre and Museum of Photography at the University of Parma (now CSAC, the Study Centre and Communication Archive). Visiting the United States, Quintavalle brought with him not only this album, on Ghirri's behalf, but other work by Ghirri and representative samples of the work of four other Italian photographers.[1] Each item was recorded in the Departmental Collection log, as the gift of its respective photographer.[2] The entire cache would languish in the departmental vaults for more than thirty-five years before Quentin Bajac, the then newly appointed chief curator of photography, tracked down the work by Ghirri that he suspected was at the Museum.[3] Bajac believes that MoMA's rediscovered holdings of Ghirri's photographs, consisting of "three distinct but connected bodies of work that formed the core of [the artist's] 1978 retrospective and of his seminal book of the same period, *Kodachrome*, . . . constitute . . . the best representation of Ghirri's early work outside Italy."[4] The Museum is now for the first time publishing this unique and hitherto all but unknown album in celebration of its timely reemergence at a moment of increasing recognition of Ghirri's significance in the history of photography.

Ghirri compiled this album at roughly the time he abandoned his early career as a surveyor, although he would remain true to that profession's commitment to objective documentation—if at the same time infusing his pictures with metaphorical connotations.[5] "I am not interested in images and 'decisive moments,' the analysis of language in and of itself, aesthetics, the concept of an all-consuming

idea, the emotion of the poet, the erudite quotation, the search for a new aesthetic creed, the use of a style," Ghirri wrote in 1978. "My duty is to see with clarity . . . to see the hieroglyphs I have encountered and make them recognizable."[6] He was interested in the unassuming artifacts of contemporary life—real and re-presented—in urban peripheries, particularly near Modena, where he lived at the time, captured in color "because the real world is not in black and white."[7] Ghirri occupied an unusual position between artistic circles, inspired by the Conceptual and participatory practices of the Modena-based artist Franco Vaccari as well as by Walker Evans's persistent attention to advertising and vernacular architecture. Ghirri's early exhibition history reflects this capaciousness: from a solo show at Light Gallery (1980), then New York's leading commercial venue for photography, to the landmark multi-artist exhibition held later that year at the Musée d'Art Moderne de la Ville de Paris, *Ils se disent peintres, ils se disent photographes*, which prodded the boundaries between photography as reportage and photography as art. Alongside his artistic practice, Ghirri founded a publishing house, Punto e Virgola, in 1977, wrote extensively, and worked actively as a curator.[8]

 Cardboard Landscapes carries within its pages evidence of Ghirri's unfettered approach to the medium of photography: pictures of paintings and pictures of photographs—pictures of pictures, more broadly—are interwoven with representations of "nature" and images that evoke the universe of "photography." These multiple, and occasionally indistinguishable, visual layers suggest an affinity with Lee Friedlander, an American counterpart who also might have said: "I look for photomontage in reality. Reality has become a colossal photomontage. Different objects overlap in complex relationships, recalling the technique and practice of classic photomontage, repurposing the typical mechanism of upending expectations."[9] *Cardboard Landscapes* may be seen, then, as an instruction manual teaching us *"come pensare per immagini"*—how to think through images—a phrase found, aptly, in the headlines of a newspaper abandoned in the gutter which Ghirri happened upon, camera in hand. For Ghirri, the phrase "holds the essence of all my work."[10]

 The series Cardboard Landscapes was first exhibited in 1974 at Il Diaframma, a gallery in Milan, accompanied by a modest paperback publication titled *Paesaggi di cartone*, comprising thirteen offset color reproductions and a text by the critic Massimo Mussini in which he concludes, "The individual subsumed by mass culture does not find it aberrant to replace nature, the real, with the advertising message, made of cardboard."[11] Curiously, Ghirri trimmed and pasted six of those reproductions into the album now in MoMA's collection, nestling them among chromogenic color prints that have, over time,

revealed their material vulnerability.[12] This indifference to material consistency is in keeping with Ghirri's open attitude toward the multitude of sources of imagery found in his photos. His delight in hybridity and multiplicity make it unsurprising that he soon folded many of the images from this series into the broader investigation that would take form in his best-known book of photographs, *Kodachrome* (1978). Indeed, Ghirri warned against a fixed approach to his work: "I consider reality complex and supple and not reducible."[13] As you pore over the pages of this album, you will encounter a world of pictures that are nothing if not enigmatic engagements with that irreducible reality.

1. Memo to Italian Customs dated March 13, 1975, Department of Photography correspondence files. The memo was left with the photographs, possibly to provide documentation regarding their exportation. The other photographers referenced are Mario Cresci (b. 1942), Antonio (Nino) Migliori (b. 1926), Roberto A. Salbitani (b. 1945), and Franco Vimercati (1940–2001).

2. In addition to this album, Quintavalle gave Szarkowski (on behalf of the artist) Ghirri's *Week End*, a boxed portfolio of thirty-one color prints; and forty-seven individual dry-mounted prints of Ghirri's work. Franco Fontana (b. 1933) was not mentioned in the customs memo, although his work was accepted for the Departmental Collection along with the others.

3. Unaware of the (historically, largely administrative) distinction between the Departmental Collection and the Museum Collection, Ghirri noted that his work was in MoMA's collection as early as 1978, although technically this would not be true until it was promoted to the Museum Collection in 2013.

4. Bajac, Department of Photography acquisition files, May 9, 2013.

5. Ghirri's estate maintains a website filled with information about the artist's life and work. See https://archivioluigighirri.com/biography.

6. Luigi Ghirri, introduction to *Kodachrome* (1978), reprinted in *Luigi Ghirri: The Complete Essays 1974–1991* (London: Mack, 2016), 19.

7. See Massimo Mussini, "Luigi Ghirri, Attraverso la fotografia," in *Luigi Ghirri* (Milan: Federico Motta Editore, 2001), 30. Translated here by Alessandra Nappo.

8. See Quentin Bajac's essay in Laura Gasparini with Adele Ghirri, *Un'idea e un progetto. Luigi Ghirri e l'attività curatoriale*, exh. cat. (Reggio Emilia, Italy: Biblioteca Panizzi, 2013), 9–11.

9. Luigi Ghirri, *Lezioni di fotografia* (Macerata, Italy: Quodlibet Compagnia Extra, 2010), 66. Translated here by Alessandra Nappo.

10. Ghirri, *The Complete Essays*, 23.

11. Untitled text by Massimo Mussini in *Paesaggi di cartone* (Modena: Samar, 1974), n.p. Translated here by Alessandra Nappo. An identical edition of this booklet was published at the same time by Il Diaframma in Milan.

12. While we encourage readers to look closely to see if they can tell which is which, the offset color reproductions can be found on pages 28 (recto), 29 (recto), 31 (verso), 33 (verso), 34 (recto), and 37 (recto). Pages 32 (recto) and 36 (verso) are also in the 1974 paperback but are represented in the album as chromogenic color prints.

13. https://archivioluigighirri.com/biography. This quotation appears under the section heading "1979."

Major support is provided by The Museum of Modern Art's Research and Scholarly Publications endowment established through the generosity of The Andrew W. Mellon Foundation, the Edward John Noble Foundation, Mr. and Mrs. Perry R. Bass, and the National Endowment for the Humanities' Challenge Grant Program.

Produced by the Department of Publications, The Museum of Modern Art, New York

Christopher Hudson, Publisher
Curtis R. Scott, Associate Publisher
Hannah Kim, Business and Marketing Director
Don McMahon, Editorial Director
Marc Sapir, Production Director

Edited by Don McMahon
Designed by Amanda Washburn
Production by Marc Sapir
Printed and bound by Robstolk, Amsterdam

This book is typeset in Adobe Jenson Pro. The paper is 150 gsm Munken Pure

Published by The Museum of Modern Art
11 West 53 Street
New York, NY 10019-5497
www.moma.org

Library of Congress Control Number: 2020933900
ISBN: 978-1-63345-102-5

Distributed in the United States and Canada by
ARTBOOK | D.A.P.
75 Broad Street
Suite 630
New York, NY 10004
www.artbook.com

Distributed outside the United States and Canada by
Thames & Hudson Ltd
181A High Holborn
London WC1V 7QX
www.thamesandhudson.com

Printed and bound in the Netherlands